D1417734

Artists' Portraits by Alex Kayser

Photograph opposite of Andy Warhol and Alex Kayser by Eliza Paley

Biographical Index compiled by Emily Berns

Library of Congress Catalog Card Number: 79-55824
International Standard Book Number: 0-8109-2222-3

© 1981 Alex Kayser

Published in 1981 by Harry N. Abrams, Incorporated, New York
All rights reserved. No part of the contents of this book may be
reproduced without the written permission of the publishers

Printed and bound in Japan

Acknowledgments
Thanks to Leo Castelli, Pierre Matisse, Ivan Karp. Thanks to
Robert Indiana for helping me with the Nevelson portrait, and
Andy Warhol for the foreword. And thanks to the people of the
Casino in Cadaques, Spain, for their marble table studio space.

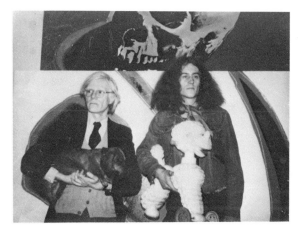

Artists' Portraits by Alex Kayser

Harry N. Abrams, Inc., Publishers, New York

An Andy Warhol Interview with Alex Kayser

Alex: I just make pictures. I was at the lawyer's office yesterday for my immigration papers and the woman there, she must have been sixty or sixty-five years old, asked me what I did. So I told her that I take photographs and am involved with video—a lot of things that could be considered narrative. She said: "What are narrative photographs?"

A.W.: Narrative art.

Alex: I had to tell her something.

A.W.: Narrative photographer?

Alex: ... sounds like soap opera photographer. I first came to the States in the early seventies to do a thesis on American photographers. I was studying with Otto Steinert in Germany then. He was the greatest. It was at the time when photography was first gaining recognition as a fine art in Europe. Ten years ago, almost no one showed photographs. So I came to America and traveled across the country visiting everyone that I knew about: Wynn Bullock, Ansel Adams, Minor White, Duane Michals, and so on. This was a great experience and it gave me lots of courage.

A.W.: Courage?

Alex: A kick?

A.W.: A kick.

Alex: I started to refuse all commercial jobs and concentrated on my own personal work. It's funny, it made me feel really good to be arrogant and not work for anyone. Do you want a beer?

A.W.: Thanks.

Alex: So I photographed all the photographers and interviewed them.

A.W.: Wasn't this published?

Alex: The photographs, yeah, in some magazines.

A.W.: Were these your first portraits?

Alex: No, I photographed actresses, German pop singers, Paris subway drivers, bullfighters and policemen in Spain, but it was not the same. It was a different

feeling. When I got a bullfighter, all I knew was, that he was a bullfighter—a kind of stereotype. The artists I knew, because I knew their art work.

Andy, this is Lyn!

A.W.: Hi!

Lyn: Hi!

Alex: Wait! Let me take a picture of your dog, Andy. Stand still.

A.W.: Your dog is white, isn't it?

Alex: Yeah, except for the wheels. They're green, blue, red, and yellow.

A.W.: I have the same camera, but the trigger fell off when I took it outside last winter.

Alex: Really?

A.W.: …must have been the cold. Then what happened?

Alex: I photographed Andy Warhol. This was in 1974. I thought I couldn't go back to Europe without a portrait of him—just like visiting Paris and not having been on the Eiffel Tower. Can you talk about yourself in the third person?

A.W.: Why not?

Alex: The Andy Warhol portrait became the first one in the series.

Lyn: Why does your accent sound Swedish instead of Swiss?

Alex: It's Danish.

A.W.: Are you Danish?

Alex: No. A friend of mine in Spain is. I like him a lot, so sometimes I use his accent.

A.W.: What did you do after you photographed Andy Warhol?

Alex: I photographed some of my friends. Then I met David Hockney at his opening at the Claude Bernard Gallery in Paris. He invited me to the party and the next day over to his house, where we did the flower portrait and some narrative sequences.

A.W.: What happened then?

Alex: I don't remember, I have to make something up.

A.W.: O.K., what are you making up?

Alex: I don't know. What do you suggest?

A.W.: I don't know. We should ask someone to help us.

Alex: Oh, I remember. Hockney introduced me to some other people like Mick Jagger, whose picture I took the

following day. Later I met Oldenburg at the art fair in Basel and soon I started to work more systematically.

Lyn: Why did you take these pictures?

Alex: What do you say when someone asks you this? It always turns my head around. I don't know why I take these pictures. Portraits are a good balance to my other work. Plus I used to be a collector—my house in Europe is filled with bits and pieces. I also collect these portraits—it's a little like collecting stamps. There are about five times as many portraits as those appearing in this book.

A.W.: How did you decide which portraits to use?

Alex: I chose the pictures together with my publisher. I wanted to put in Andy Warhol, Chagall, Rauschenberg, etc., and some of my friends. My publisher preferred to put in Andy Warhol, Chagall, Rauschenberg, etc. So, we agreed on this.

A.W.: Why do you color them in?

Alex: I wanted to work in color but didn't like Kodak colors. When you work in black-and-white and suddenly you want color, you just don't want any more black-and-white.... It's like when I was playing rock 'n roll in Switzerland. Many of the songs didn't make sense, because I couldn't really speak English. We just went like: "hey! baby, baby, gotta ... gotta ... do it ... come on...." We didn't think about the why, we just did it. The feeling was there and the audience went crazy anyway. The voice was more like an instrument. What we had to tell was done through an emotional outlet and received by the people in the same way. What were we talking about?

Lyn: Kodak colors.

A.W.: Do you like Kodak colors now?

Alex: Sure. They're all right.

A.W.: Were the portraits set up?

Alex: They're staged. Staging a photograph can give you absolute control over the whole picture. Many of them were taken in five minutes, because I knew what I wanted. Spending a lot of time shooting is not necessary. When I get a good picture, I stop. A few frames are better than ten rolls. Of course, some of them took longer, like the Dali one, because there were a lot of people involved.

A.W.: How was the Dali done?

Alex: Everybody asks me the same. Is it a montage? No. Where was it taken? Where did you get the boys and girls?

A.W.: Who invents the poses?

Alex: Almost always myself. Usually I know in advance what kind of atmosphere the picture should have.

A.W.: Do people like them?

Alex: Yes. But if I say yes it doesn't mean anything. I don't know what people think—I don't really consider it. Chagall said that the series is very dramatic. Other people find it amusing, and George Segal said that he doesn't think that I have too much respect for the artists, and he liked the critique between the lines. Maybe I got close to what I wanted when friends and rivals of the person photographed both tell me that it's one of the best portraits they've seen. Do you remember the Rockefeller portrait that was reproduced on the cover of the VILLAGE VOICE right after he died... the grinning expression?

A.W.: Why are the portraits of well-known people?

Alex: Perhaps curiosity. Not all of them are of well-known people, but it's always simpler to photograph someone you know about. In the beginning it was like seeing behind the curtain in a theater. Like everybody I believed in the mystique—the aura which has grown around some people. I remember standing in a crowd in front of a Francis Bacon triptych in a Paris gallery. Everyone stood silent and it felt like in a church. The more people I photographed, this feeling of reverence disappeared and was replaced by a sense of respect for specific individuals.

A.W.: Are you trying to expose the art world?

Alex: That sounds exaggerated. I'm not that serious. Would you like another beer?

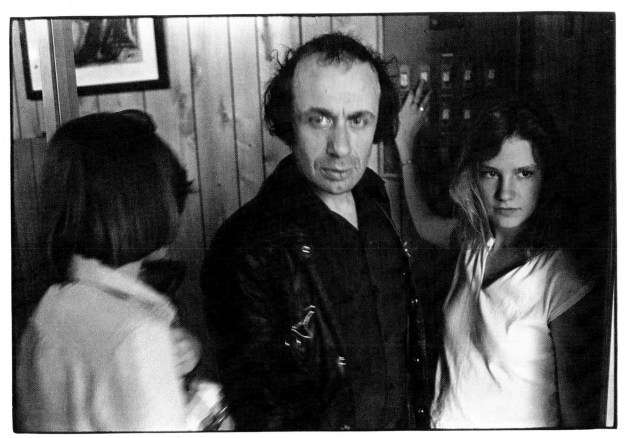

vito acconci 1978

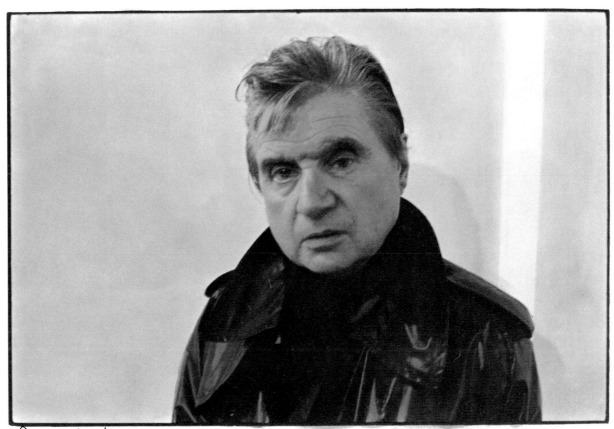

francis bacon 1977

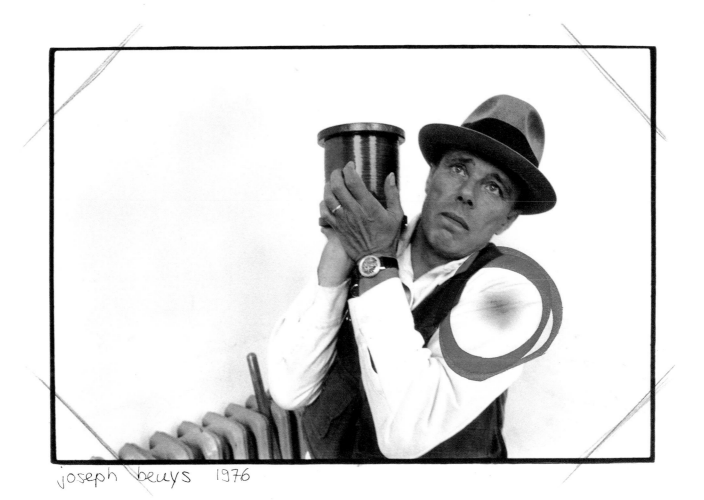

joseph beuys 1976

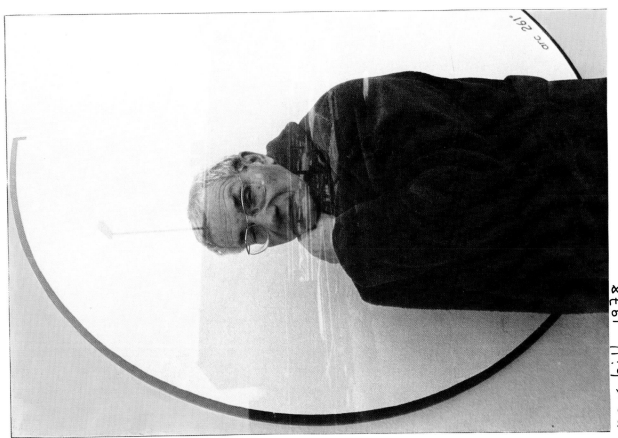

max bill 1978

arc 261.

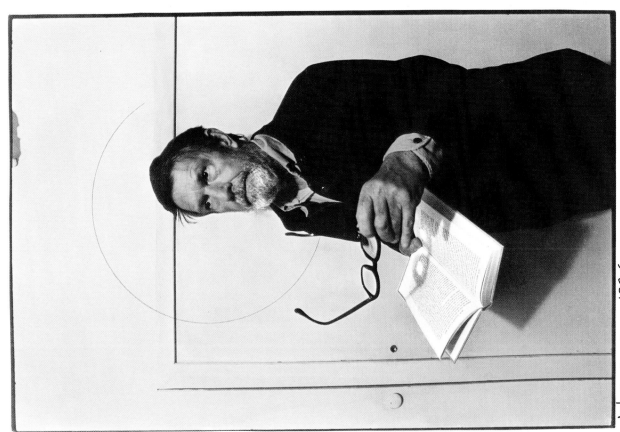

john cage 1976

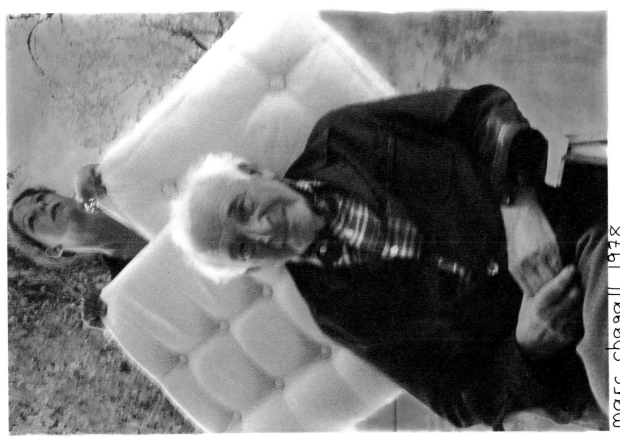

marc chagall 1978

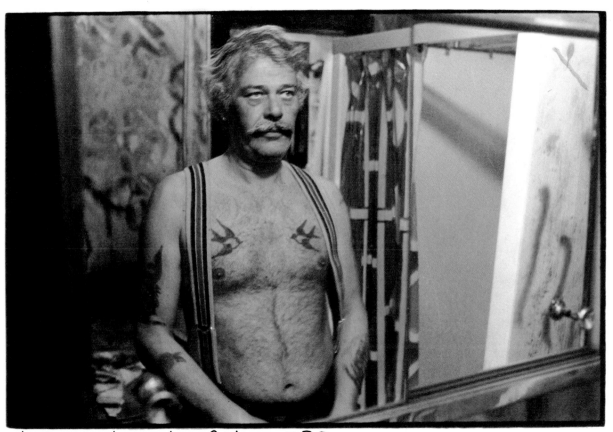

john chamberlain 1977

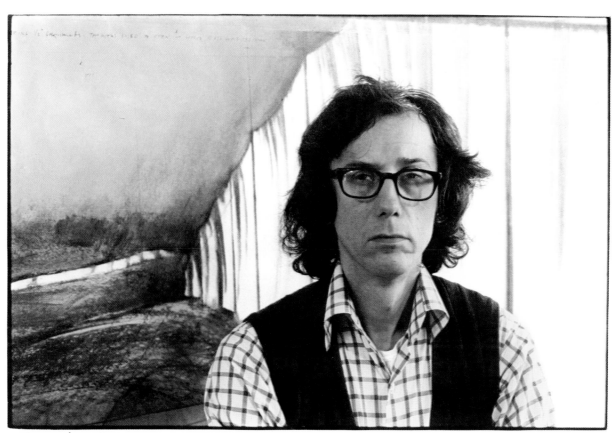

christo 1976

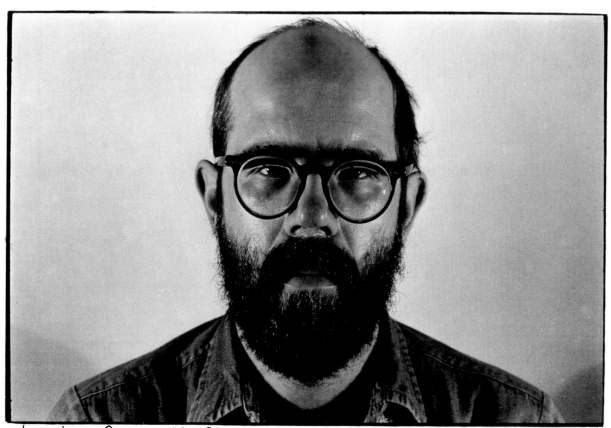

chuck close 1976

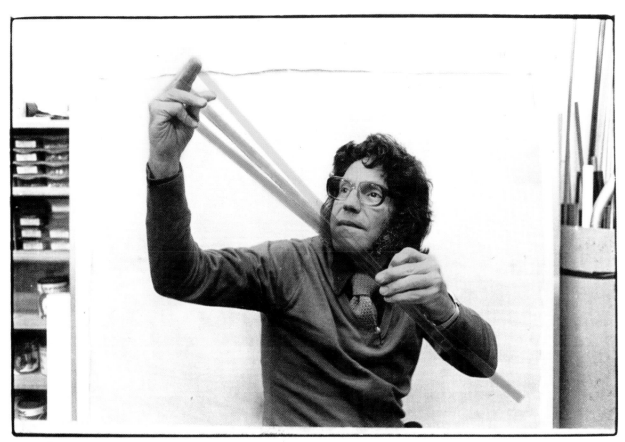

carlos cruz-diez 1976

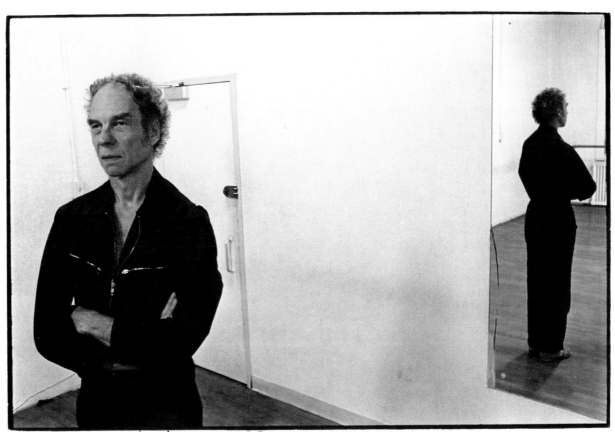

merce cunningham 1977

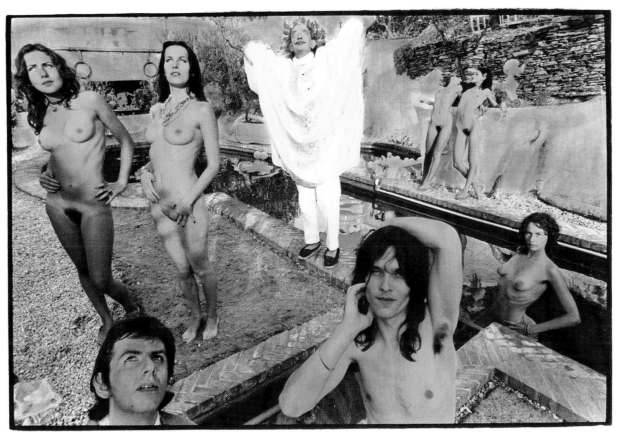

salvador dali 1975

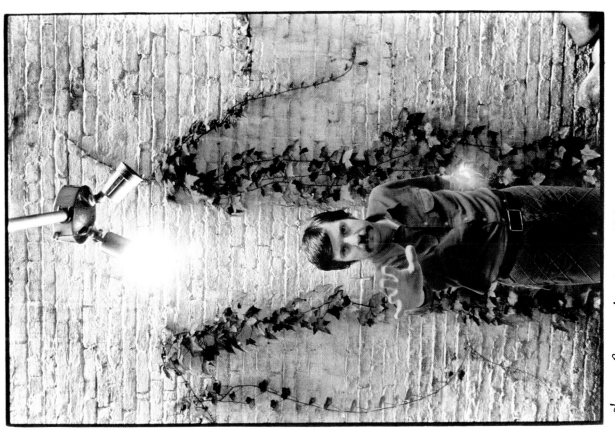

douglas davis 1977

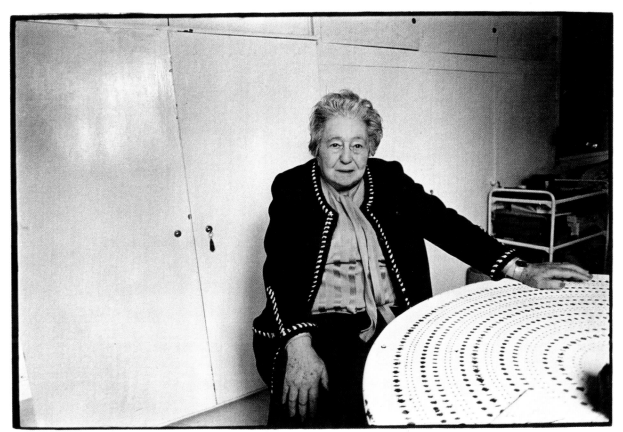

sonia delaunay 1975

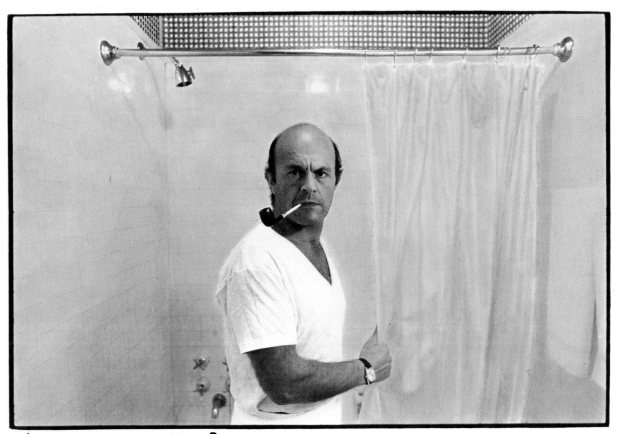

jim dine 1977

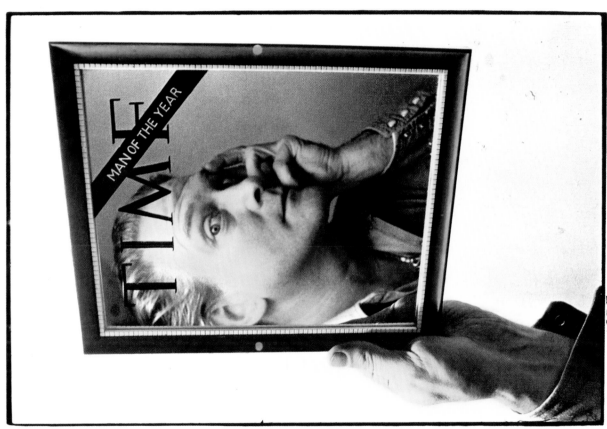

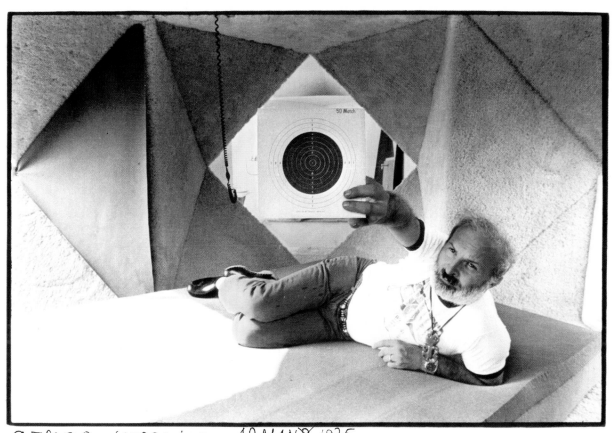

arman fernandez ARMAN 1975

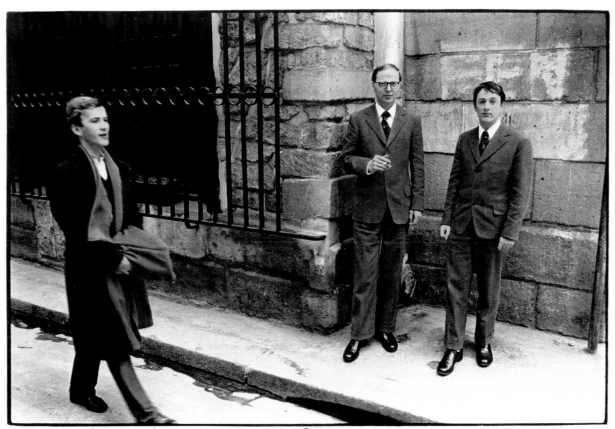

gilbert and george 1977

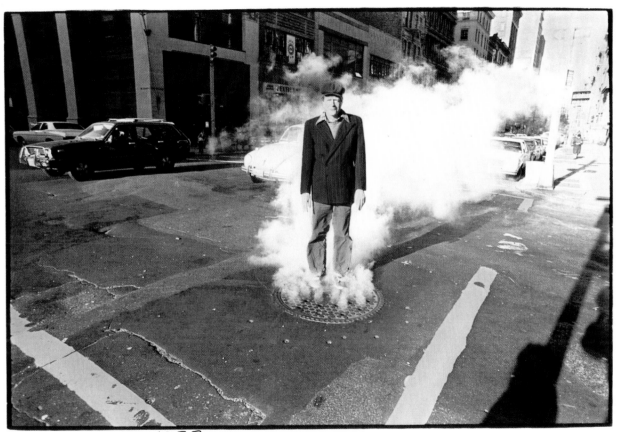

red grooms 1977

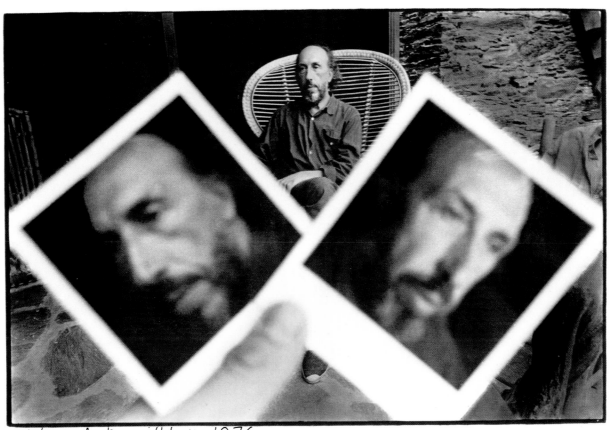

richard hamilton 1976

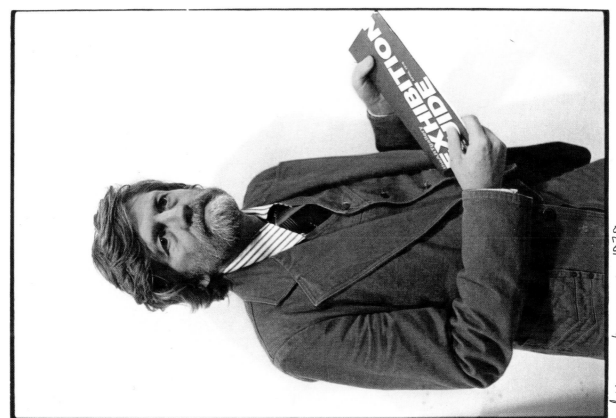

Duane Hanson 1978

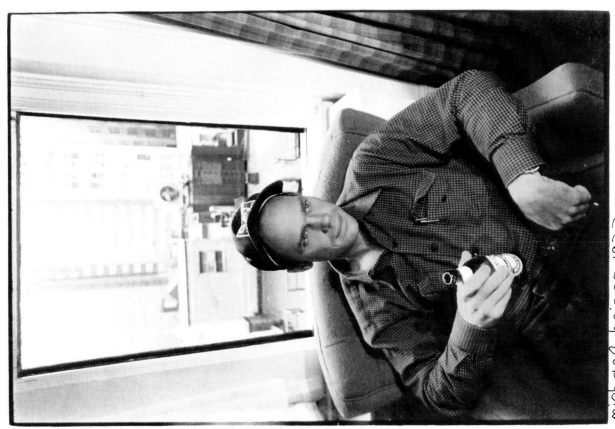

michael heizer 1977

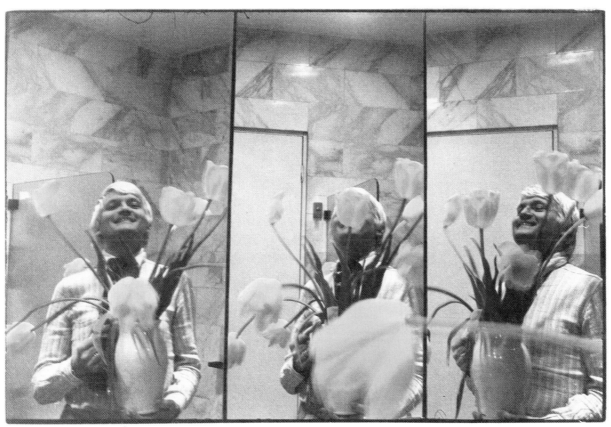

david hockney 1975

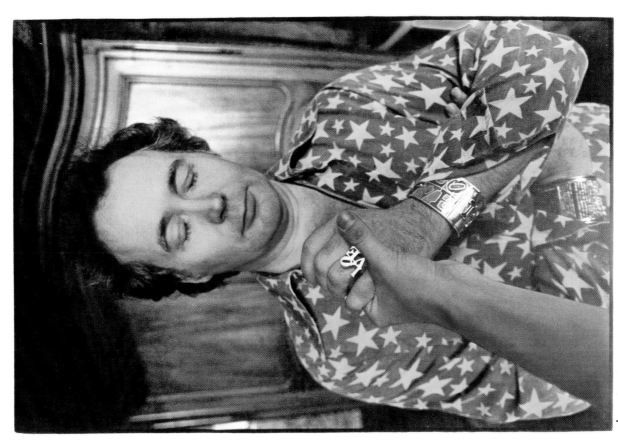

bob indiana 1946

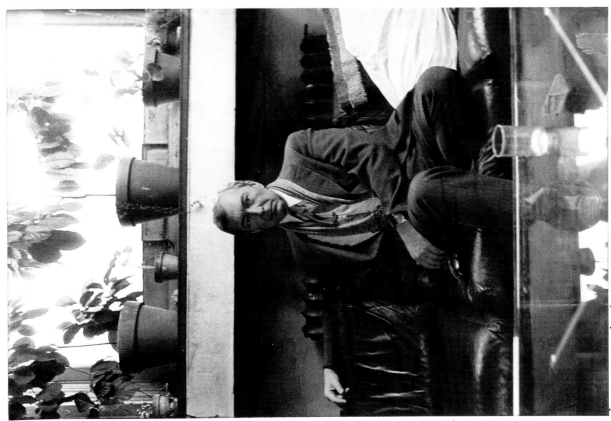

Jasper Johns 1978

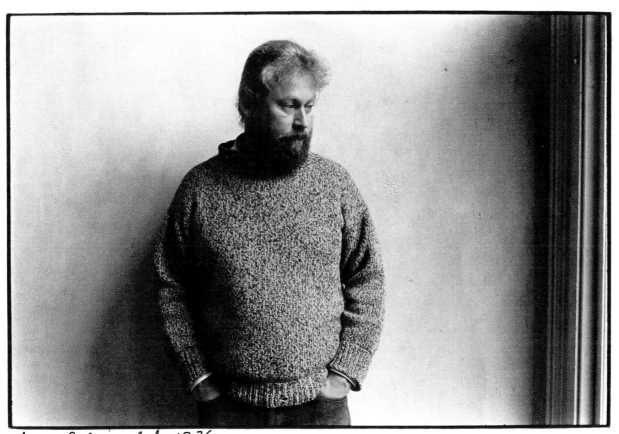

donald judd 1976

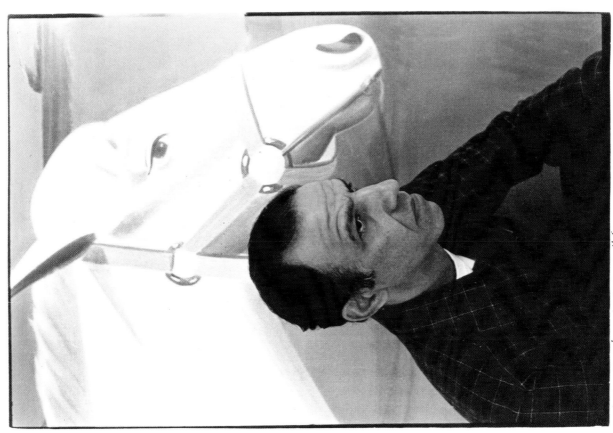

alex Katz 1976 11/25

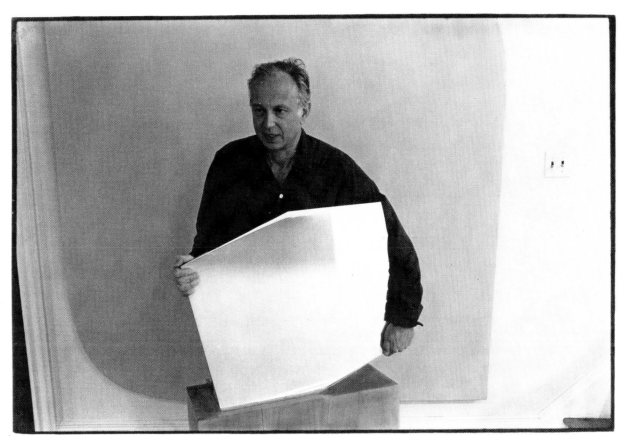

ellsworth kelly 1977

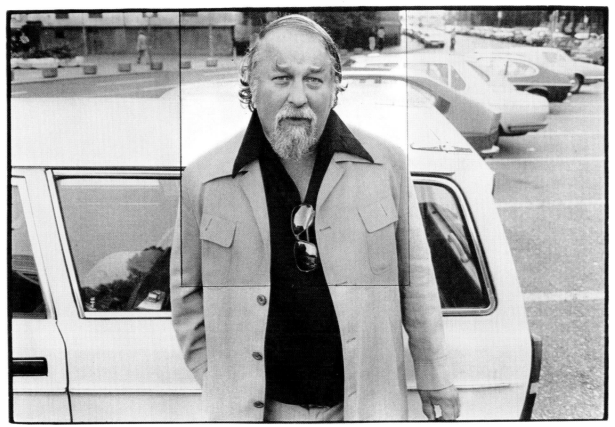

edward kienholz 1977

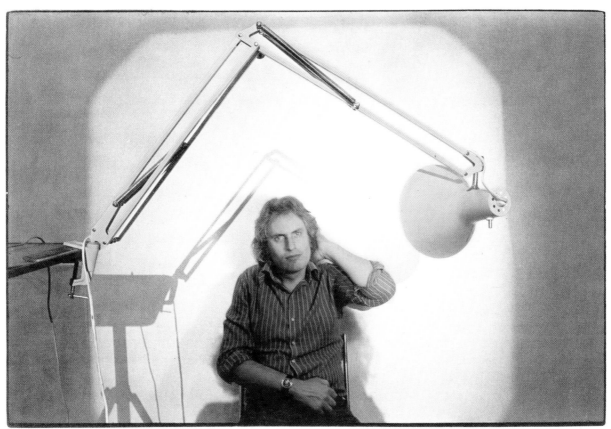

peter klasen 1975

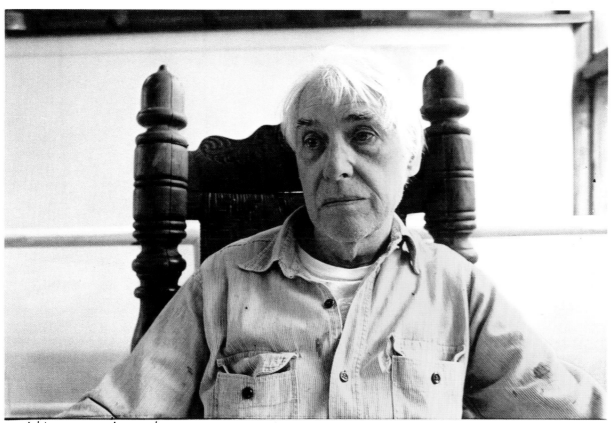

willem de kooning 1978

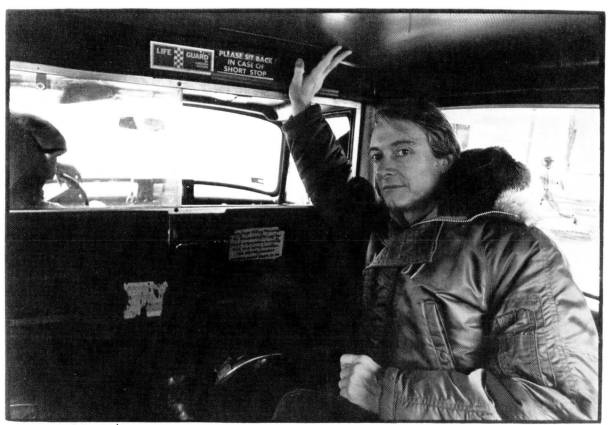

roy lichtenstein 1976

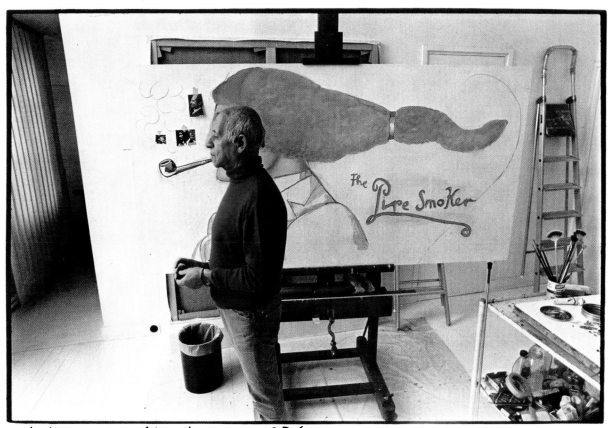

richard lindner 1976

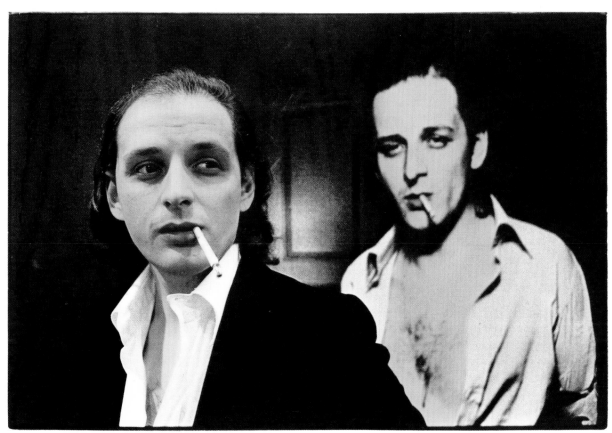

urs lüthi 1975

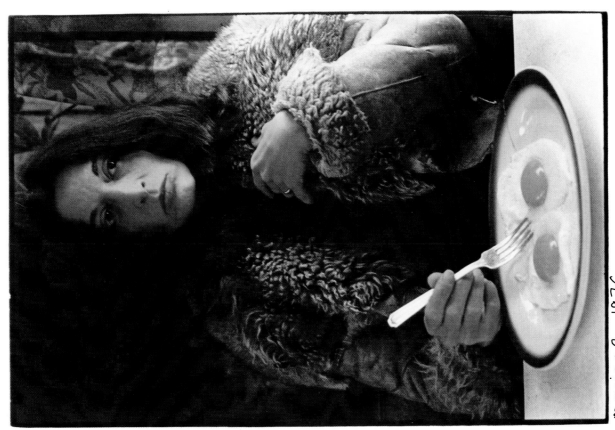

marisol 1976

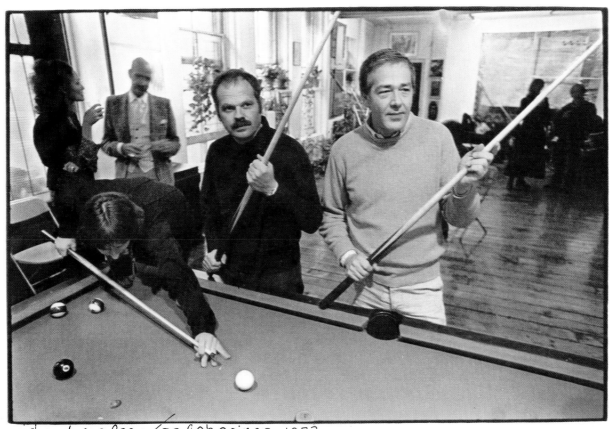

richard mc lean / ralph goings 1977

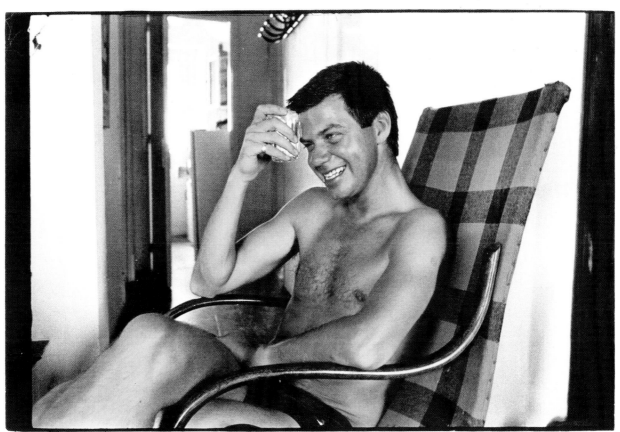

keith milow · 1978

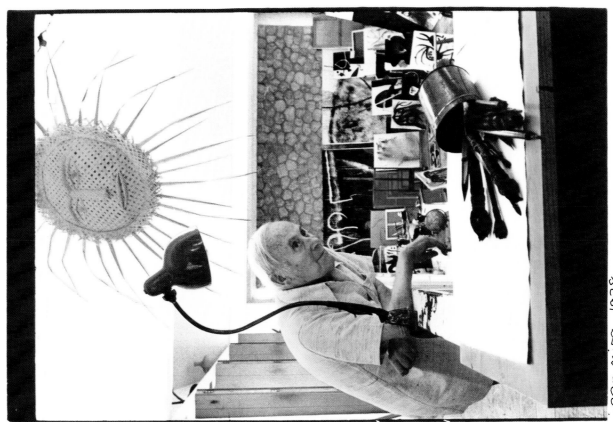

joan miro 1978

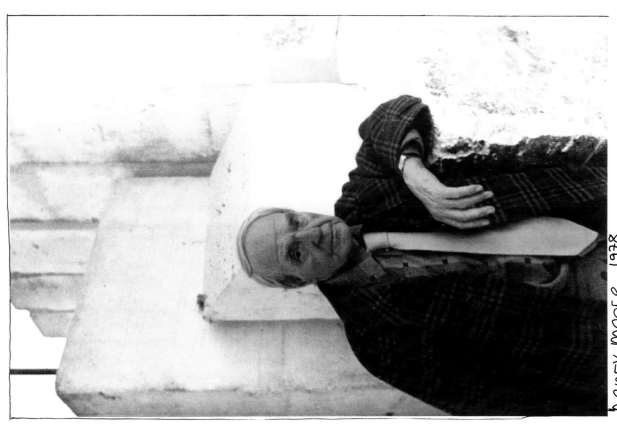

henry moore 1978

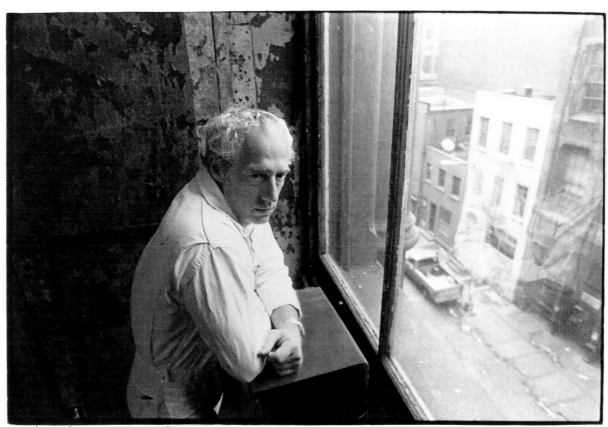

robert morris 1977

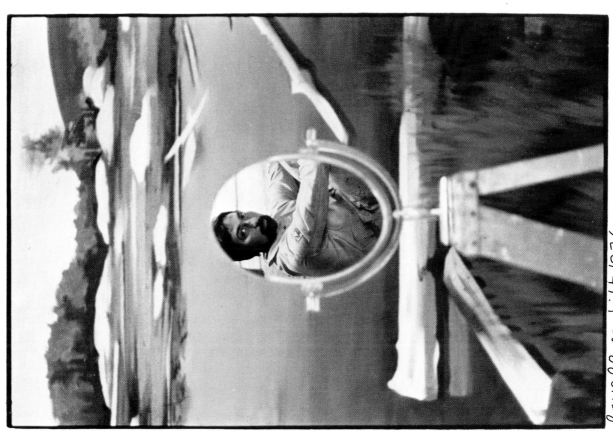

lowell nesbitt 1976

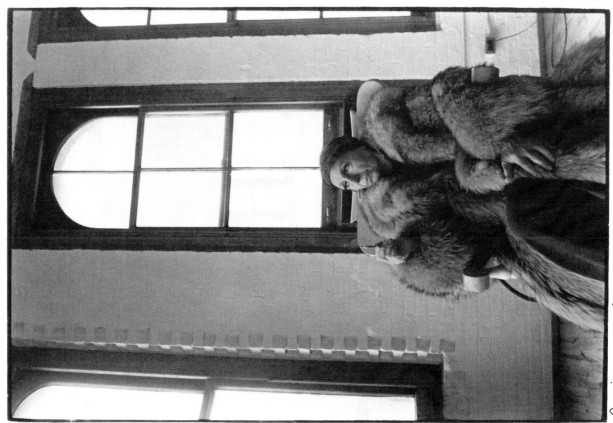

Louise Nevelson 1977

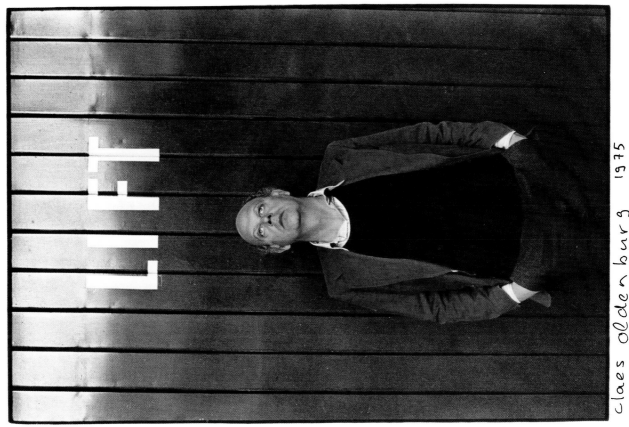

claes oldenburg 1975

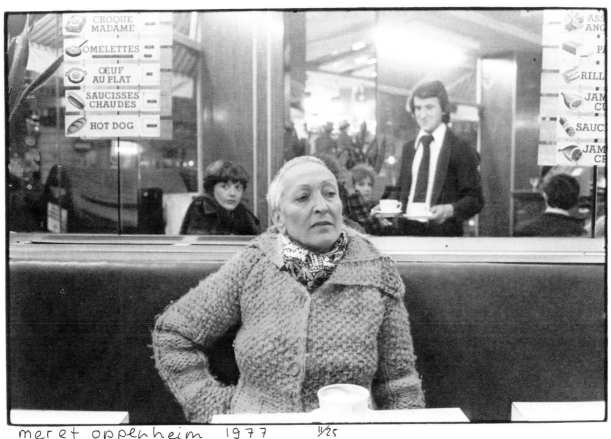

meret oppenheim 1977 11/25

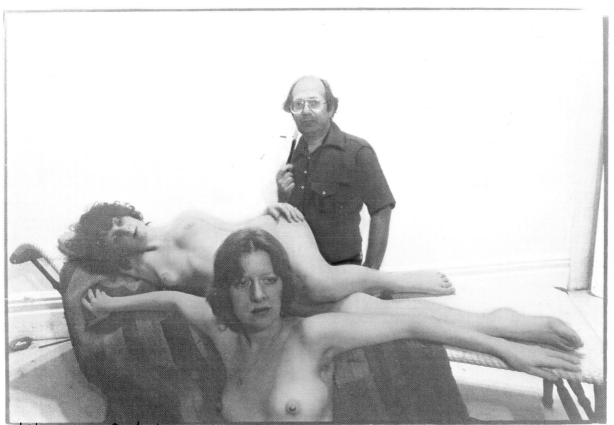

philip pearlstein

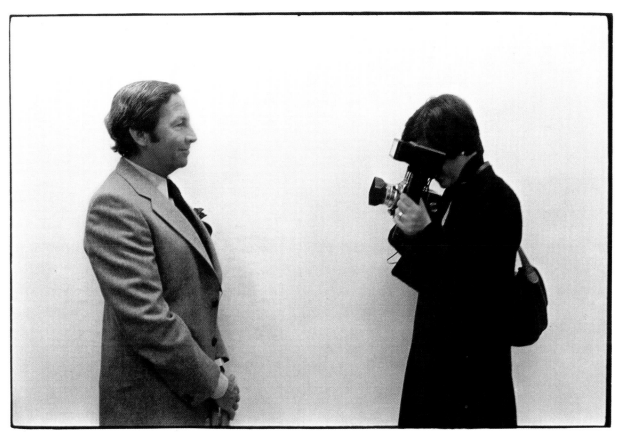

bob rauschenberg 1977

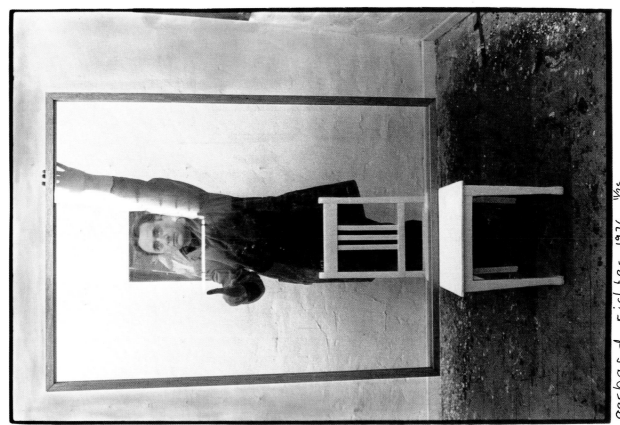

gerhard richter 1976 1/25

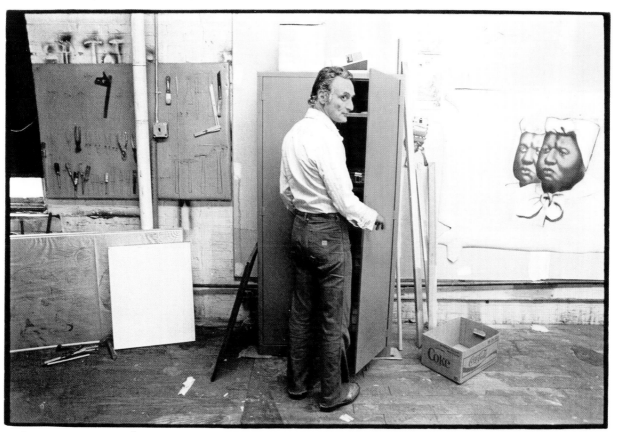

larry rivers 1977

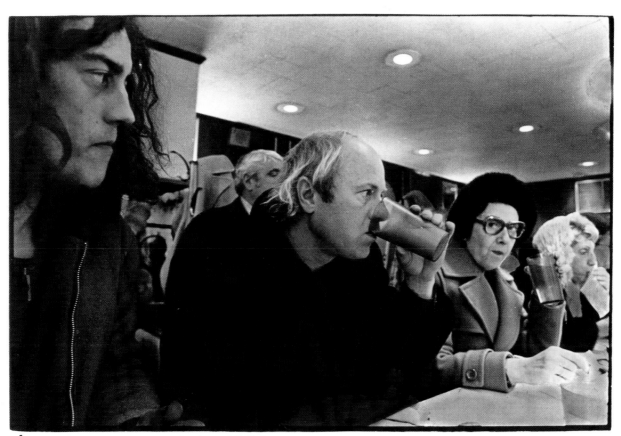

james rosenquist 1976

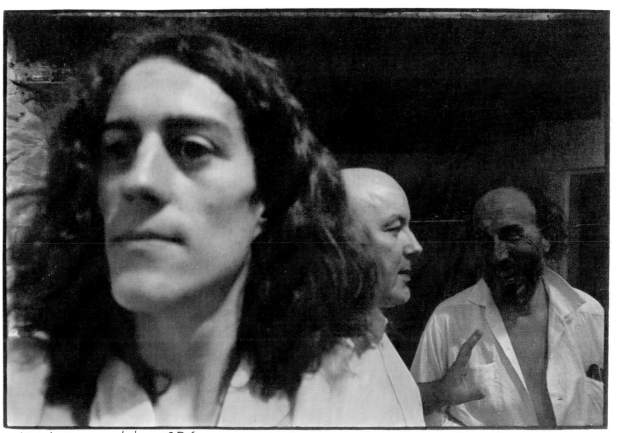

ditter rott 1976

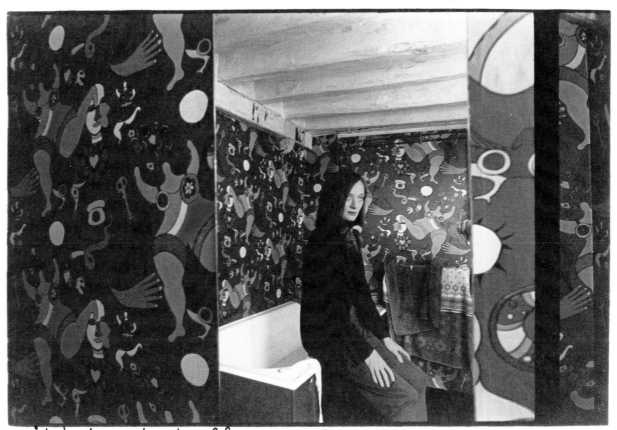

niki de st. phalle 1977

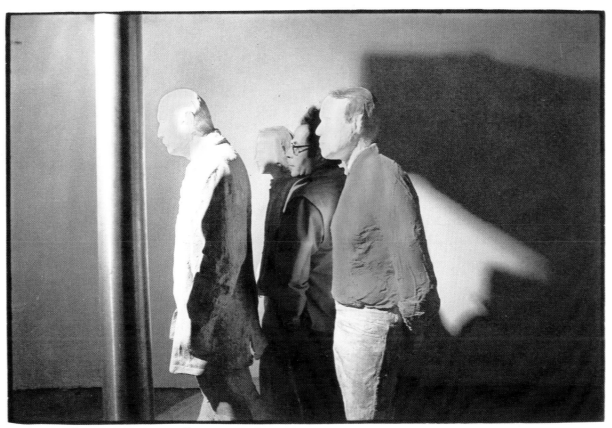

george segal 1977

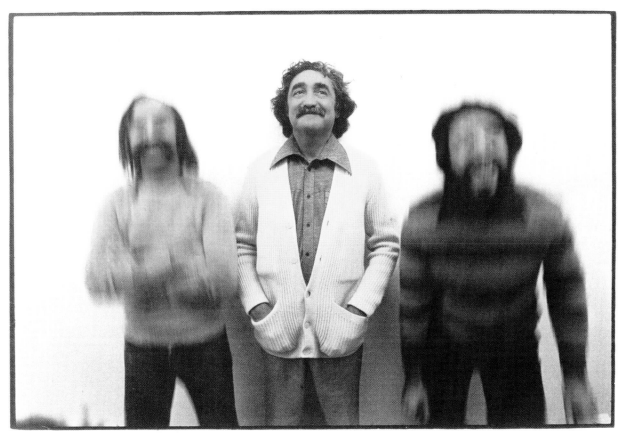

jesus raphaël soto 1976

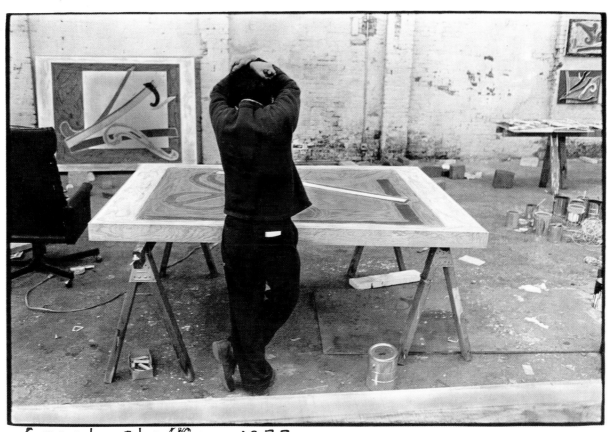

frank stella 1977

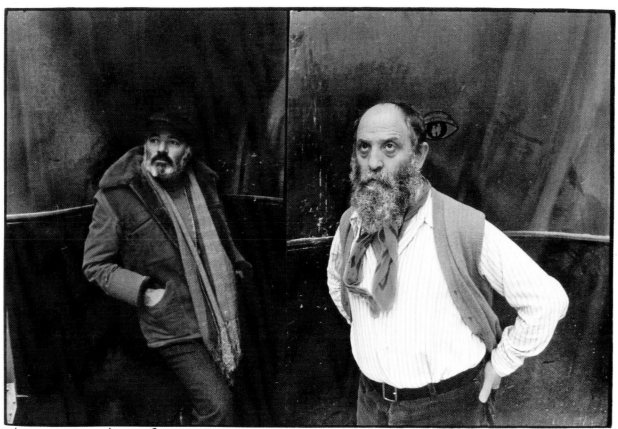

takis et césar

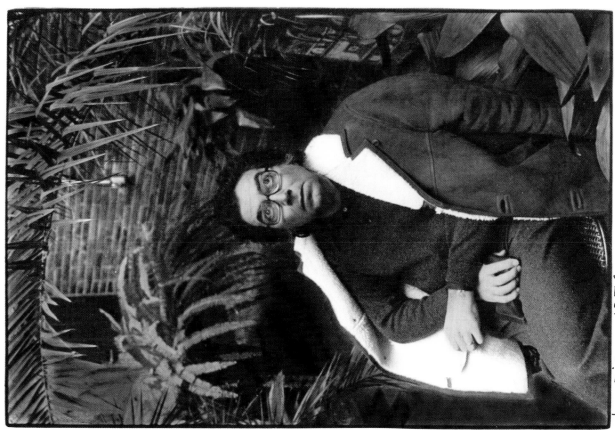

tapies 1976

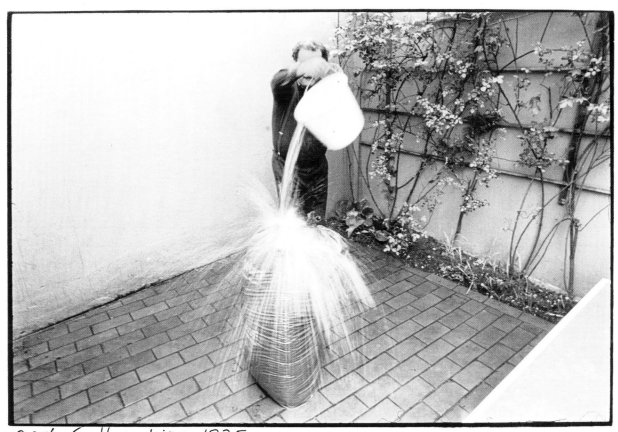

andré thomkins 1975

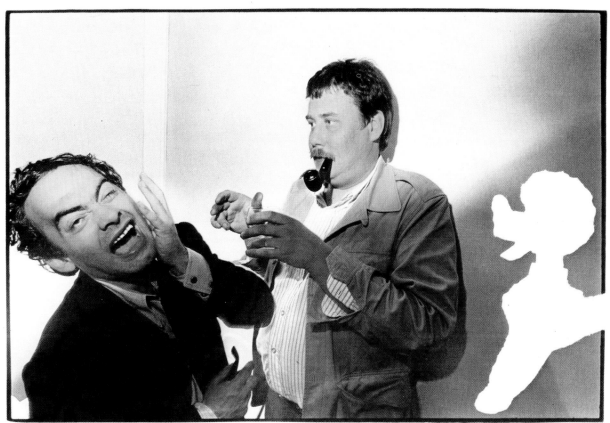

roland topor & eric dietmann 1976

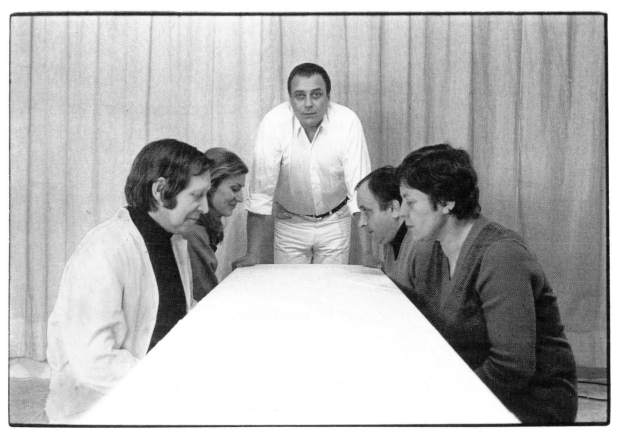

günther uecker 1976

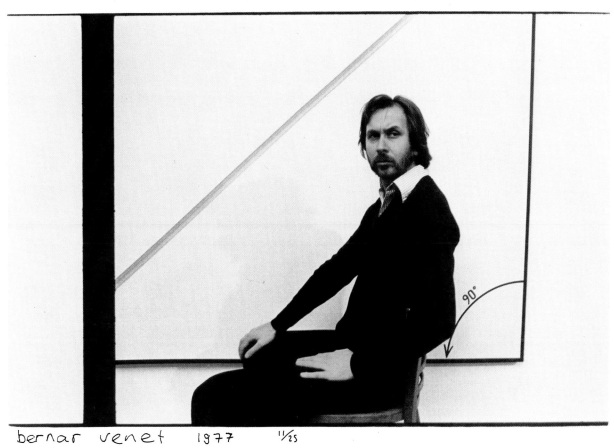

bernar venet 1977 11/25

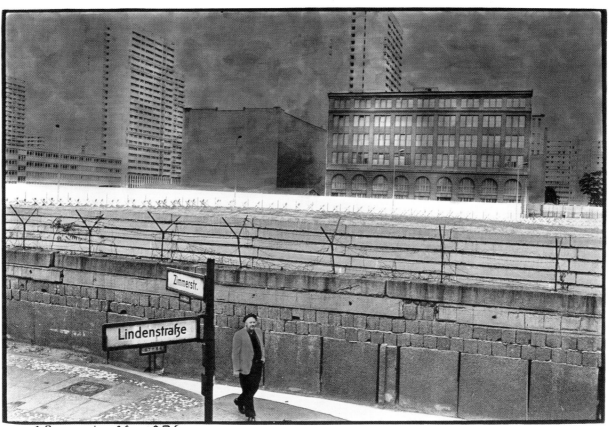

wolf vostell 1976

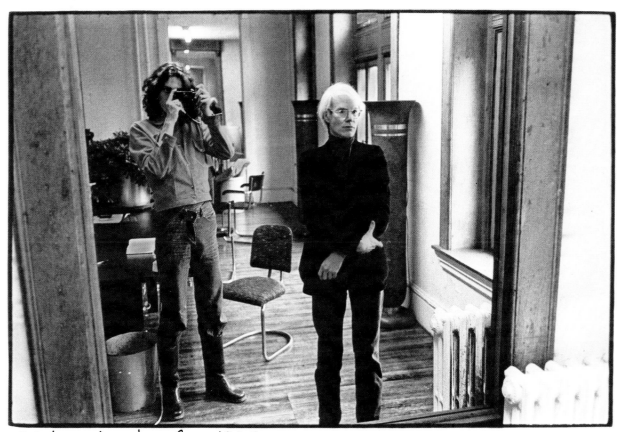

andy warhol 1974

Biographical Index

Vito Acconci
American: born January 24, 1940, New York, New York.
Performance artist: video tapes and live actions, featuring the artist's body as the means of expression.

Armand Fernandez (Arman)
French/American: born November 17, 1928, Nice, France.
Painter/Sculptor: delicate imprints of objects on paper, and assemblages of objects presented out of their usual contexts and often broken, burnt or sliced.

Francis Bacon
British: born October 28, 1909, Dublin, Ireland.
Painter: disturbing personal interpretations of old-master-painting themes, characterized by distortion and deformation.

Joseph Beuys
German: born 1921, Kleve, Germany.
Performance artist: actions featuring the artist's verbal meditations on art, in which objects, textures, and the artist's own body and personality are used like characters in a drama.

Max Bill
Swiss: born December 22, 1908, Winterthur, Switzerland.
Architect/Sculptor/Painter: studies in the harmonious relationships of colors, and of geometric shapes.

John Cage
American: born September 5, 1912, Los Angeles, California.
Composer: musical pieces incorporating everyday sounds and noises, and using them as musical instruments.

César Baldaccini (César)
French: born January 1, 1921, Marseilles, France.
Sculptor: abstract and figural sculptures in a variety of mediums and a variety of styles, i.e. metal and plastic "compressions," monumental plastic "imprints" of human features, and poured polyurethane foam "expansions."

Marc Chagall
French: born July 7, 1887, Vitebsk, Russia.
Painter: brightly colored poetic images, often incorporating references to the Jewish religion and Jewish traditions.

John Chamberlain
American: born April 16, 1927, Rochester, Indiana.
Sculptor: bright, enameled assemblages of junked automobile materials.

Christo Javacheff (Christo)
American: born June 13, 1935, Gabrovo, Bulgaria.
Environmental artist: large-scale projects for wrapping and draping urban and landscape structures, such as buildings and coastlines, using polyethylene sheeting.

Chuck Close
American: born July 5, 1940, Monroe, Washington.
Painter: translations in acrylic paint of closeup portrait photographs.

Carlos Cruz-Diez
Venezuelan: born August 17, 1923, Caracas, Venezuela.
Painter/Sculptor: visual experiments sometimes involving ridged reliefs, in which the forms painted change with the viewer's position.

Merce Cunningham
American: born April 16, 1919, Centralia, Washington.
Dancer/Choreographer: dances incorporating ordinary gestures and the element of chance.

Salvador Dali
Spanish: born May 11, 1904, Figueras, Spain.
Painter: surreal visions painted in painstaking, miniaturist's style.

Douglas Davis
American: born April 11, 1933, Washington, D.C.
Video artist/Critic: attempts to use the public medium of video to create a private, two-way dialogue with the viewer.

Sonia Delaunay
French: born November 14, 1885, Gradizhsk, the Ukraine; died December 5, 1979.
Painter/Decorator/Designer: investigations into the possibilities of color as a separate entity, disassociated from the forms of the natural world.

Erik Dietmann
Swedish: born 1937, Sweden.
Sculptor: junk assemblages, plaster-coated objects, and picture puzzles incorporating multi-lingual word games.

Jim Dine
American: born June 16, 1935, Cincinnati, Ohio.
Painter/Sculptor: gestural, abstract paintings with identifiable objects attached.

Erro
Icelandic: born July 19, 1932, Olakfscik, Iceland.
Painter: pictures based on collage models and structured through the agglomeration of forms.

Gilbert (Proesch) and George (Passmore)
British: born 1943, Dolomite Mountains, South Tyrol, Austria and 1942, Totnes Devon, England.
Performance artists: events featuring the artists, in baggy suits and metallic heads, as living sculptures.

Ralph Goings
American: born May 9, 1928, Corning, California.
Painter: straightforwardly presented photo-realist views of California settings.

Red Grooms
American: born June 1, 1937, Nashville, Tennessee.
Painter/Sculptor: environments created from cutout figures and objects, painted in strident colors.

Richard Hamilton
British: born February 24, 1922, London, England.
Painter: multi-media montages, juxtaposing fragments of everyday objects from the commercial world.

Duane Hanson
American: born January 17, 1925, Alexandria, Minnesota.
Sculptor: life-size, detailed facsimiles of human beings in polyester and fiberglass.

Michael Heizer
American: born 1944, Berkeley, California.
Earthworks artist: gigantic trenches and dirt structures in the desert.

David Hockney
British: born July 9, 1937, Bradford, Yorkshire, England.
Painter/Graphic artist: delicately drawn, carefully ordered and cooly colored images of contemporary life.

Robert Indiana
American: born September 13, 1928, New Castle, Indiana.
Painter: brightly painted emblematic images, using lettering and other hard-edged forms.

Jasper Johns
American: born May 15, 1930, Augusta, Georgia.
Painter/Sculptor: paintings, painting/sculpture combinations, and sculptures using commonplace imagery.

Donald Judd
American: born June 3, 1928, Excelsior Springs, Missouri.
Sculptor: repetitions of identical units of galvanized iron, steel or aluminum; massive outdoor concrete monuments in simple, geometric shapes.

Alex Katz
American: born July 24, 1927, New York, New York.
Painter: large, generalized, and stylized figural compositions.

Ellsworth Kelly
American: born May 31, 1923, Newburgh, New York.
Painter: color-field paintings, relating simple, pure shapes and colors.

Edward Kienholz
American: born 1927, Fairfield, Washington.
Sculptor: naturalistic theatrical tableaux, generally presented as social commentaries.

Peter Klasen
German: born August 18, 1935, Lübeck, Germany.
Painter: aerographically produced, strongly structured images, usually of mechanical objects and fragments of mechanical objects.

Willem de Kooning
American: born April 24, 1904, Rotterdam, Holland.
Painter: richly colored, energetically brushed abstractions, frequently with woman or landscape themes.

Roy Lichtenstein
American: born October 27, 1923, New York, New York.
Painter: pictures based on both popular and "high" art sources, painted in mechanical, comic-strip style.

Richard Lindner
American: born November 11, 1901, Hamburg, Germany; died April 30, 1978.
Painter: hot-colored, mysterious, often sinister images of mannequin-like figures.

Urs Lüthi
Swiss: born September 10, 1947, Lucerne, Switzerland.
Photographer/Painter: images of the artist characterized by ambivalence and self-travesty, sometimes juxtaposed to a landscape.

Marisol Escobar (Marisol)
American: born May 22, 1930, Paris, France.
Sculptor: human tableaux in wood and mixed media.

Richard McLean
American: born April 12, 1934, Hoquiam, Washington.
Painter: meticulously realistic renderings of photographs of horses.

Keith Milow
British: born December 29, 1945, Clapham, London, England.
Painter: three-dimensional painting experiments done in series and made in reference to architecture, sculpture and other neutral subject matter.

Joan Miró
Spanish: born April 20, 1893, Barcelona, Spain.
Painter/Sculptor: fantastical, often playful evocative images, using abbreviated, biomorphic forms.

Henry Moore
British: born July 30, 1898, Castleford, Yorkshire, England.
Sculptor: organic forms carved directly in stone or wood.

Robert Morris
American: born February 9, 1931, Kansas City, Missouri.
Sculptor: eclectic experiments in sculpture and in environmental and conceptual art.

Lowell Nesbitt
American: born October 3, 1933, Baltimore, Maryland.
Painter: photo-realist images—frequently cropped closeups.

Louise Nevelson
American: born September 23, 1900, Kiev, Russia.
Sculptor: monochromatic, additive wall constructions in wood.

Claes Oldenburg
American: born January 28, 1929, Stockholm, Sweden.
Sculptor: soft sculptures of hard, or otherwise incongruous, objects.

Meret Oppenheim
Swiss: born October 6, 1913, Berlin, Germany.
Sculptor: Surrealist objects, tableaux and environments, characterized by incongruous associations.

Philip Pearlstein
American: born May 24, 1924, Pittsburgh, Pennsylvania.
Painter: powerfully composed, dispassionate studies of nudes in studio settings.

Robert Rauschenberg
American: born October 22, 1925, Port Arthur, Texas.
Painter/Sculptor: painted mixed media assemblages, often including junk materials; paintings and prints using silkscreened, photo-journalist imagery.

Gerhard Richter
German: born 1932, Waltersdorf, Oberlausitz, Germany.
Painter: paintings resembling enlarged, out-of-focus photographs of domestic interiors and other familiar motifs.

Larry Rivers
American: born August 17, 1923, New York, New York.
Painter/Sculptor: eclectic images, frequently based on American historical themes and on old master paintings.

James Rosenquist
American: born November 29, 1933, Grand Forks, North Dakota.
Painter: large-scale, multi-panelled paintings juxtaposing billboard details or abstract forms.

Dieter Roth (spelled variously)
Swiss: born April 21, 1930, Hanover, Germany.
Painter/Graphic artist/Writer: calculatedly unresolved, impermanent and self-destructive images, frequently using perishable, decaying materials as media; poems with negativity and sadism as themes.

Niki de Saint-Phalle
French: born October 29, 1930, Neuilly-sur-Seine, Paris, France.
Sculptor/Painter: exuberant and decorative sculpted female figures.

George Segal
American: born November 26, 1924, New York, New York.
Sculptor: spot-lighted environments inhabited by ghostly, immobile plaster cast figures.

Jesús-Rafael Soto
Venezuelan: born June 5, 1923, Ciudad Bolívar, Venezuela.
Sculptor/Painter: spatial constructions in wood, metal, and cording, using subtle arrangements of delicate metal rods; room environments created with plastic strings.

Frank Stella
American: born May 12, 1936, Malden, Massachusetts.
Painter: experiments with symmetrical patterns, with interrelated colored shapes, and with the shape of the canvas—in paintings and in painted reliefs.

Takis (Panayotis Vassilakis)
Greek: born October 29, 1925, Athens, Greece.
Sculptor: kinetic sculptures that combine art and science through the use of natural forces such as gravity, magnetism, electromagnetism, the movement of the tides, and light.

Antoni Tàpies
Spanish: born December 13, 1923, Barcelona, Spain.
Painter: pictures with thick, textured surfaces of sand, varnishes and sometimes collage elements, painted in somber tones.

André Thomkins
Swiss: born August 11, 1930, Lucerne, Switzerland.
Painter/Draftsman/Graphic artist: delicately drawn surreal images, often characterized by palindromes and word games.

Roland Topor
French: born January, 1938, Paris, France.
Draftsman/Writer: humorous, sometimes horrific graphic images using visual puns.

Günter Uecker
German: born March 13, 1930, Wendorf, Wecklenburg, Germany.
Sculptor: canvas-covered wooden structures encrusted with nails and sprayed with white paint; also light experiments.

Bernar Venet
French: born April 20, 1941, St. Auban, France.
Conceptual artist: diagrammatic paintings and photographic blowups celebrating new discoveries of science and mathematics, presented and conceived objectively.

Wolf Vostell
German: born October 14, 1932, Leverkusen, Germany.
Creator of Happenings: carefully planned outdoor events, with violent and unsettling episodes included to heighten the performers' awareness of their everyday surroundings.

Andy Warhol
American: born August 6, 1928, McKeesport, Pennsylvania; 1930, Philadelphia, Pennsylvania; August 8, 1931, Cleveland, Ohio.
Painter/Sculptor/Graphic artist: impersonal silkscreened contemporary icons.